University of London
Academic Dress

Philip Goff

1999

Published by

The University of London Press

Senate House

Malet Street

London WC1E 7HU

ISBN 0-7187-1608-6

British Library Cataloguing-in-Publication Data

A catalogue record for this book is available from the British Library

Printed by Central Lithographic Printing Company, England

CONTENTS

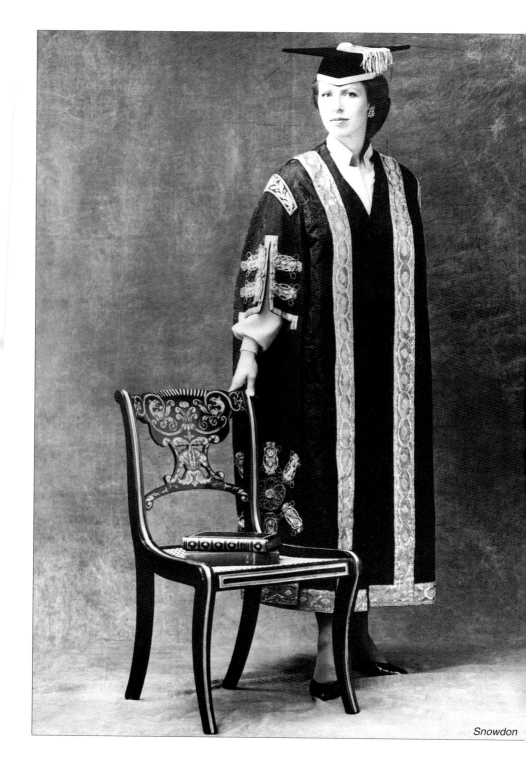

BUCKINGHAM PALACE

As Chancellor of the University of London, I attend many events where academic dress is being worn. Quite often I see a hood or a gown I do not recognise, yet there are very few sources available to point out what they signify.

I am delighted therefore to commend this booklet, which demystifies the subject and sets out in a straightforward manner the origins and development of academic dress. This will be equally useful to those who want to check what a particular colour on a hood means, and to those who are seriously interested in the history of dress.

Anne

Foreword

Graduation Ceremonies and other university ceremonial occasions would certainly be drab and dreary affairs without the splash of colour and pomp afforded by academic dress. But just to indulge academics in an opportunity to don strange costume and engage in harmless pageantry would risk Ruritanian vacuity were there not something more to it. And there is.

For our academic and official dress unites us with other universities across the world, which share our heritage and our values, and links us with the rich history of the university which reminds us that we are heirs to a great tradition.

But this significance will be lost on participants in and observers of these ceremonies if the meaning of the symbolism is not known.

I therefore welcome Philip Goff's booklet warmly, for it not only describes the dress of the University of London simply and clearly but it also explains its origins and evolution with similar limpidity. I hope this greater understanding will bring pride to our graduates and enable them and others to derive more pleasure and enjoyment from our ceremonial occasions.

January 1999

Professor Graham Zellick
Vice-Chancellor, University of London

Acknowledgements

I should like to thank Professor Graham Zellick, Vice-Chancellor of the University of London, for his interest in this booklet and for writing the Foreword. He, and many other officers of the University, have responded to my telephone calls, visits and constant questions, over the last two years, with enormous patience and kindness. Amongst those who deserve my thanks are: the Academic Registrar, Gillian Roberts; Susan Johnson in the Academic Office; Margaret Brown in the Presentation Ceremonies Office; the University Librarian, Emma Robinson and the University Archivist, Ruth Vyse.

Keith Scruton, the Printing Services Manager of the University Central Printing Service, and the Printing Manager, Simon Cole have not only tolerated my endless revisions and corrections without any visible signs of frustration but have offered very welcome professional expertise and assistance. I would like to thank them along with John Chappell of Chappell Graphic and Chris Christou of London Offset Colour.

Above all, I am indebted to Barbara Anderson, Head of Public Affairs at the University of London, for her encouragement and good-humoured assistance in the production of this booklet. Without her many hours of work on the original design and lay-out it would have remained only an idea.

Finally, my thanks are due to many individuals at Ede & Ravenscroft and William Northam and Co., official robe-makers to the University of London, for their very kind help with examples of robes, photographs and access to their archives.

Philip Goff
June 1999

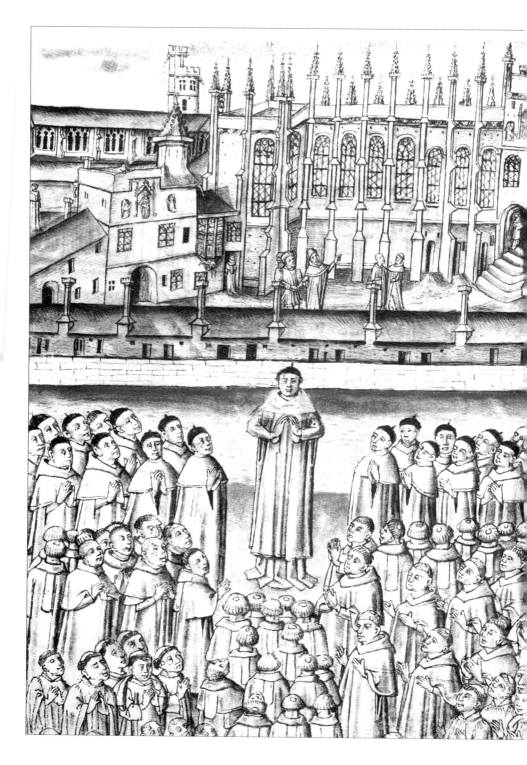

Although academic dress is sometimes worn at school functions, and by Anglican and some other clergy in church, it is at a degree ceremony that most people will see it. In Britain, the traditional outfit of gown, hood and cap has survived through Reformation, Civil War and Restoration periods, linking today's graduates with students at medieval universities and the cathedral schools from which they evolved nearly one thousand years ago. At a time when all kinds of ceremonies and traditions are being questioned, and indeed, abandoned, it is curious to note that not a single new British university has decided against such a system of special costume.

There are several books, old and more recent, which deal with this fascinating subject, and they are good reference guides. The academic dress of Oxford and Cambridge, and of some of the new universities, are described in small illustrated booklets, but I noticed that my own university had nothing similar. The spring and summer of 1997 provided an opportunity for me to be involved with the design and revision of academic costume at the University of London, which was a most enjoyable task, and led to this booklet becoming a reality. I hope that it will be of help and provide some answers to graduands, parents, members of staff and guests who, at graduation ceremonies, ask questions about the colourful robes on display.

PFMG

In memory of Bill Keen

A History of Academic Dress

The Development of Universities

The earliest European universities evolved from cathedral schools. These schools were known as *studia* or recognised schools.

By 1150, two great places of learning had emerged, Bologna and Paris. Scholars from all over Europe travelled to these cities, drawn by their high reputation. Bologna was particularly concerned with the study of law and Paris with theology and the arts.

Later, as they evolved, their success was rewarded by recognition from the Pope. As *studia generalia* they were able to organise their own affairs free from interference.

Paris was the first to be recognised in this way and enjoyed the Pope's patronage. Meanwhile, Bologna in 1158 came under the patronage of the Emperor, Frederick Barbarosa.

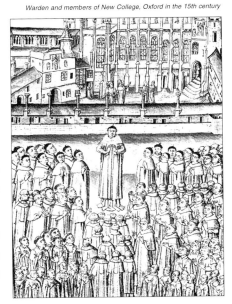

Warden and members of New College, Oxford in the 15th century

During the 13th century, the word *universitas*, a Roman legal term for a corporation, replaced *studium generale*. These two great universities became the models for others in Europe.

At Paris, the University was governed by the Masters (teachers) and this system was taken up in northern Europe.

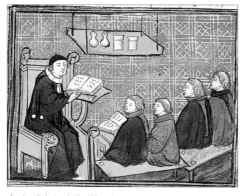
A university lecture in the 14th century

At Bologna, authority was exercised by the student body. The professors formed a separate college of Masters outside the university. This system has been followed in southern Europe. The other great university of the Middle Ages was Oxford, which followed the system at Paris. Life in a medieval university was sometimes violent. Fights would often break out between students and townspeople. Scholars, being clerics, were regulated by ecclesiastical rather than civil law and the punishments were less severe. It was as the result of a particularly violent skirmish between scholars and locals that an exodus from Oxford led to the formation of Cambridge University.

Degrees

During the 13th century, a system or hierarchy emerged:

• Scholars - attended lectures;

• Bachelors - student teachers seeking a licence to teach;

• Masters (doctors/professors) - graduates who were obliged to teach for two years.

Doctor, like master and professor, meant learned man or teacher. Originally the terms were synonymous. During the 14th century, 'doctor' began to be used more for higher degrees in Canon Law, Civil Law and Medicine, and 'master' for Theology and Arts.

In the early universities, a distinction existed between Regents and non-Regents, i.e. those actively engaged in teaching work at the university and those who had completed their teaching or were not suitable.

The Origins of University Costume

Academic dress has its origin in the everyday dress of men and women in the Middle Ages. This consisted of a tunic (or *toga*) over which might be worn a cloak. Over the tunic or cloak, to protect the head and shoulders, would be a hood.

The tunic or toga

The ancient universities began as communities of scholars and teachers in a religious school around a great cathedral or monastery. Students at the early

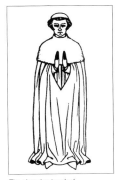
The closed outer cloak

european universities, Bologna, Paris, Oxford and Cambridge, for example, were clerics (clerks). They were not necessarily priests but were, at least, in minor holy orders. As such they were subject to church law and discipline and were expected to dress soberly. Their dress, like that of the parish clergy, was quite similar to that of everyone else but was particularly distinguished by being long and closed. Their outer cloak was closed with one or two openings for the hands (see illustration).

This closed cloak or *cappa clausa* was ordered for all the secular clergy by Stephen Langton, Archbishop of Canterbury, at the Council of Oxford in 1222 to bring English clergy into line with those in the rest of Catholic Europe. The monastic clergy, of course, wore their various habits and were easier to regulate. Whilst this order was frequently ignored by parish clergy - often reprimanded for their zeal for the latest fashions (see illustration on page 14) - the universities retained the *cappa clausa* and it became the main item of academic dress at Bologna, Paris and Oxford.

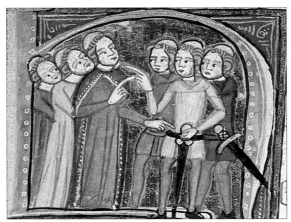

Clergy in the 14th century being reprimanded for wearing modern fashions

The closed cloak still exists in some forms today, such as the parliamentary robe worn by bishops at a State Opening or Coronation; and in the cope worn by the Vice-Chancellor of Cambridge University (or his deputy) when conferring degrees. It is a long scarlet robe with a deep hood lined with fur.

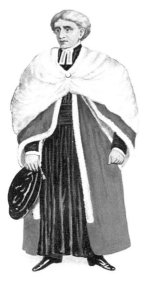

In the second half of the 15th century, the trend in fashion moved towards shorter, more open costume – reflecting the new openness in the world of ideas, learning and the arts. The heavy outer dress was increasingly left off and the undergarment, the tunic or *toga*, became the outer garment.

From 1470 onwards, outer clothing was worn open in the front and sleeves increased in size and varied in style. From 1490 onwards, it was fashionable for linings or facings of silk or fur to be seen at the front of garments or in sleeves.

The Vice-Chancellor's cope used at Cambridge

The Gown

By 1500 at Oxford and Cambridge, and elsewhere in Europe, the closed cloak had been abandoned in favour of the tunic or undergarment which was now open at the front and worn with sleeves. This robe, the *tunica* or *toga*, was the ancestor of the university gown as we know it today, as well as of the clerical cassock.

Oxford Bachelor of Laws, 1482

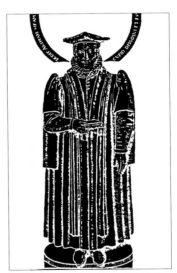

Oxford Doctor of Divinity, 1615

Originally the gown, whether as the closed outer cloak or later the tunic, might have been blue, brown, green or another colour. From the late 15th century, darker colours predominated. Holinshed, the chronicler of Elizabeth I, attributed this change to the influence of the universities. In the 17th century, because of the Puritan influence, black became the norm. Doctors, however, have a tradition of wearing scarlet because of privileges granted by popes or monarchs and also because scarlet dye was very costly and thus represented something of worth.

In Britain, the traditional styles have been affected by Reformation, Commonwealth and Restoration periods; by Italian and French fashions; and by both ecclesiastical and lay dress.

For centuries, the shape of a university gown sleeve indicated the degree it represented, but the advent of so many new universities, each requiring a distinctive system of robes, has changed things.

As a rough guide, however, Bachelors wear gowns with long, pointed wing-like sleeves; Masters wear gowns derived from Tudor fashions

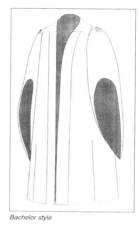

Bachelor style

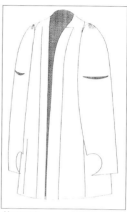

Master style

with long closed sleeves, and Doctors usually have a black gown for ordinary use, based on the Master's design, but they nearly always have a full-dress robe in scarlet cloth. For PhDs, the robe is more often in another shade of red, like claret or crimson.

Several of the newer universities have introduced a wide range of diffent colours into their systems of academic dress.

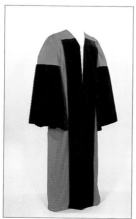

Oxford DD robe

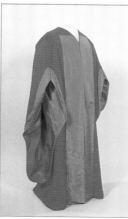

Cambridge MD robe

The Hood

Medieval hood

The medieval hood consisted of three parts: the cowl, or hood proper, which protected the head; a cape, to which the cowl was attached, which usually covered the shoulders, and often reached to the elbows; and the tail of the hood (called a *liripipe*) which could be short and serve to pull the hood from the head, or long enough to wind around the head or shoulders like a scarf. When worn back off the head, the hood also served as a pouch or bag for carrying food or implements.

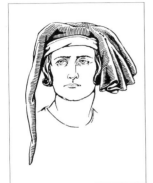

Hood (chaperon) worn on head

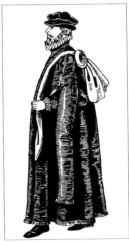

Chaperon on civic robe

By 1450, this kind of hood was no longer worn in ordinary dress. Instead, it evolved in various ways. One popular fashion was to put the face-hole or cowl of the hood on the head and to roll up the cape like a turban. Sometimes it was

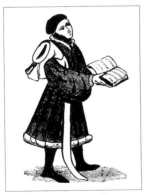

Hood (chaperon) worn on shoulder

simply draped over the shoulder. This form of the hood was known as the *chaperon* and it survives today, as a tiny remnant, on a barrister's gown or on the robes of some civic dignitaries and orders of chivalry. Meanwhile, at the universities the hood went through a different evolution.

At first the hood was retained intact as part of clerical academic dress, but it came to be worn less frequently on the head after clerics began to wear skullcaps. In the winter months, the hood could be lined with fur and in the summer with silk. Judges still keep this tradition of alternating silk and fur lined robes, and the medieval shape of the hood lives on in a judge's ceremonial costume.

By the 16th century, the hood had been modified greatly, losing most of its former shoulder cape and slipping further down the back. Wigs and ruffs made the traditional hood awkward and it was no longer required as an actual head-dress.

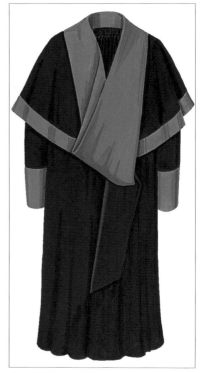

Circuit Judge's ceremonial robe

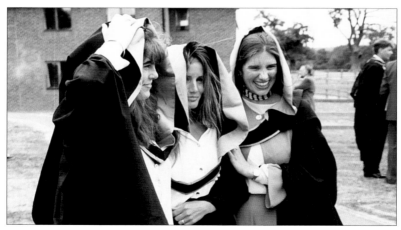

University of London Graduates at the Royal Veterinary College

Over time the front of the cape was opened up and the hood dropped back and held in place by a neckband, much as may be seen today. In the illustration (page 18) some graduates of the Royal Veterinary College, on a rather windy day, instinctively put their hoods over their heads.

The Reformation in the 16th century brought great upheaval in Europe and by the 18th century academic dress had been retained for normal wear only in Britain, Spain and Portugal. In Britain, the influence of the Establishment kept it intact and a powerful church discipline did the same for Spain and Portugal. In France and Germany, and elsewhere on the

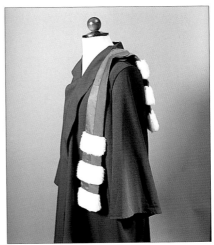

French épitôge

continent during the 16th century, the cowl and cape of the hood were abandoned but the *liripipe*, or tail, was retained and worn as a scarf on the shoulder. Known by various names - *épitôge; chausse; sendelbinde* - this scarf (a vestigial hood) is still prescribed by French universities today for graduates, but in practice is rarely worn.

The Revolution, which swept away universities for a time, is perhaps the explanation for the absence of a French degree ceremony such as we have in Britain. However, graduates of French universities may be seen wearing the *épitôge* at degree ceremonies in English-speaking countries, and some British institutions have recently adopted this garment as an alternative to the academic hood.

Today the hood comes in some basic shapes with several variations. Hoods which still have some part of the cape attached are called *full shape*, such as (overleaf) Cambridge, London and Oxford doctors.

Full Shape:

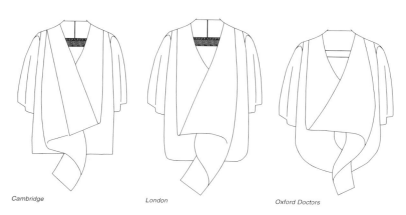

Cambridge London Oxford Doctors

When folded flat they look like this:

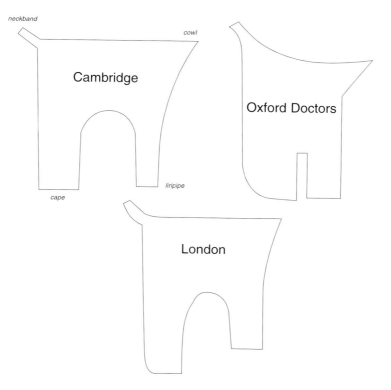

Simple shape:

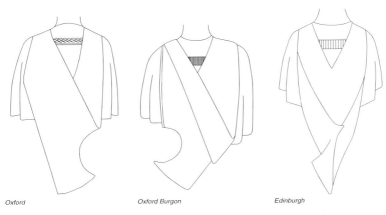

Oxford Oxford Burgon Edinburgh

Those with none or hardly any of the cape surviving are called simple shape, such as (left to right) Oxford, Oxford Burgon and Edinburgh.

When folded flat they look like this:

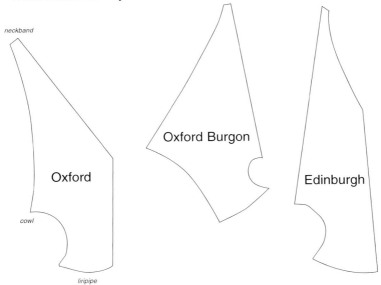

neckband

Oxford Burgon

Oxford

Edinburgh

cowl

liripipe

The Cap

Skullcap

There are several types of academic head-dress and most have a common ancestry. The hood itself would have served as a head covering until it

Pileus (round cap)

went out of fashion and was worn only on the back. It was replaced by the skullcap which would have fitted well over the tonsured (shaven) heads of the clerks (clerics) who were the students and teachers at the early universities. Made from four pieces of cloth sewn together, the skullcap developed to form both the raised round cap *pileus rotundus* and the square cap *pileus quadratus*.

The round cap, which is still prescribed for French doctorates today, also forms part of a doctor's outfit at Sussex University. The square cap has several variations. It was introduced to the University of Paris around 1520 and probably spread from there to England in the form which is very familiar

Canterbury cap

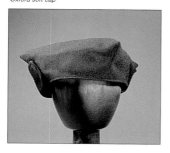

Oxford soft cap

to us from 16th century portraits of the clergy.

A version of this cap, known as the Canterbury cap, is still used by some Anglican clergy today; and as an alternative to the mortar-board for women at some universities, where it is called the Oxford soft cap.

This square cap also developed in another direction, becoming very large and floppy. This was the origin of the mortar-board, trencher or college cap. Originally the mortar-board was a square cap worn over a skull cap. Eventually the two caps became joined.

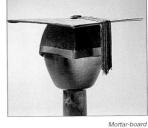

Mortar-board

In the 17th century the cap

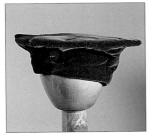

Bishop Andrewes' cap

became stiffened by board. A pompom or tump was worn in the centre and in the 1770s this gave way to a tassel. The original style with pompom is retained at Cambridge for the DD and is known as the Bishop Andrewes' cap.

On the continent, the square cap evolved into the biretta - a cap worn until the 1960s by Roman Catholic priests. It is still part of the costume of many Catholic universities, and is worn by judges as well.

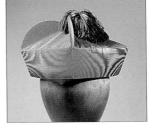

Biretta

John Knox cap

In Scotland, a soft square velvet cap is known as the John Knox cap.

Another round or oval cap is known as the Tudor bonnet.

Tudor bonnet

This cap has a stiff brim and a gathered crown, as in a beefeater's cap. It usually has a twisted cord and tassels around the crown. This is the doctoral cap most often seen at graduation ceremonies.

The Chancellor's Robe

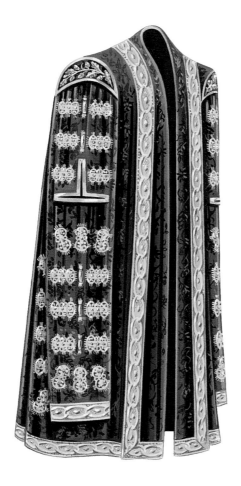

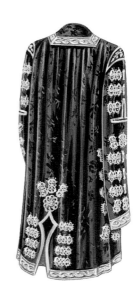

All of the pre-1992 British universities have at their head a Chancellor - usually someone royal, famous, well-known or well respected. This office is prescribed in their royal charters. Many of the post-1992 universities have now appointed Chancellors too. The office of Chancellor is formal and ceremonial.

The word 'chancellor' has the same origin as the verb 'to cancel' from the Latin *cancellare* meaning to make criss-cross bars on something. In medieval churches, as still sometimes today, the eastern part of a church, the chancel, was separated from the nave. The official who sat there, *ad cancellos*, 'at the bars' or criss-cross of the building, was known as the Chancellor. In fact, many older cathedrals still have a Chancellor. This word came to be applied to great officers of state. It is used as such today.

The robe worn by the chief officer of many universities, usually the Chancellor, is similar to that worn by the Lord Chancellor, the head of the judiciary, and many Lord Mayors. The Speaker of the House of Commons, the Master of the Rolls and the Lords Justices of Appeal also wear robes of similar type. It is not really an academic robe but one which marks out an important dignitary. It dates from the 17th century and replaced earlier more academic-type costume.

Usually the Chancellor's robe is made from figured silk damask, most often black but sometimes blue, green or even red. The sleeves, facings, collar and hem are usually decorated with gold lace or braid in the form of bars known as 'frogs'. The robe is usually very heavy. The Chancellor's mortar-board is often made of velvet and decorated with gold braid, button and tassel. Very often the other officials of the university (including the Vice-Chancellor, who is the university's executive head) will wear similar robes of decreasing splendour according to their rank.

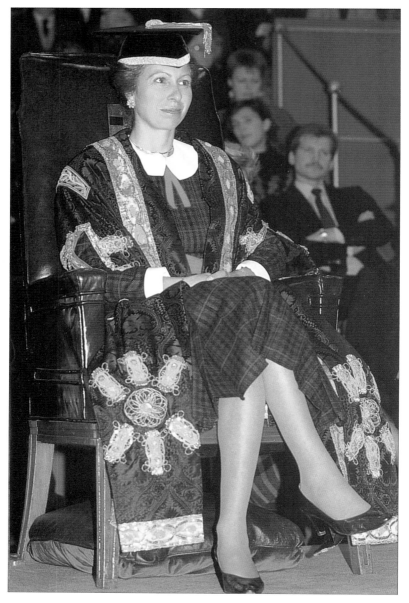

HRH The Princess Royal, Chancellor, University of London

Academic Dress in the University of London

The University of London began in 1828 following a letter to *The Times* in 1825. In 1829, King's College London was founded in reaction to what was seen as a secular university. The earlier institution later became University College. In 1836, a royal charter was granted empowering the University to grant degrees.

When the subject of official costume was first debated in the Senate in 1839, it was thrown out, but on 18 October 1843, a clergyman wrote the following to Dr R W Rothman, the Registrar:

> *Sir,*
>
> *Having been, as a graduate of your University, ordained as a clergyman, I should feel obliged by your informing me whether any distinctive hood has been adopted, or whether the University allows clergymen, its graduates, to wear hoods of Oxford and Cambridge, the Canon[1] making it imperative upon clergymen being graduates to wear hoods.*
>
> *I would further ask, whether any particular gown has been adopted for graduates of the University of London.*
>
> *I am, Sir, your obedient servant,*
>
> *F. Harrison Rankin.*

In the following month, on 22 November 1843, at its meeting the Senate resolved "that a committee be appointed to consider the expediency of authorising the wearing of gowns and hoods by graduates of this University and the wearing of gowns by the matriculated students; and also the proper patterns for such gowns and hoods".

On 28 February 1844, the Vice-Chancellor (a Cambridge graduate) reported that academic dress should not be thought of as a requirement, but those who wished so could wear the following:

[1] Church law

Undergraduates: As for St John's College, Cambridge but with black velvet facings.

BA: A Cambridge BA gown with black facings and a black hood faced with black velvet.

MA: A Cambridge MA gown with black velvet facings and a black hood with lavender silk.

BL BM DL DM: The same gown but with distinctive hoods.

Caps for undergraduates, BA, BL, BM - a black mortar-board with black velvet button and for the MA, DL, DM a black velvet square cap.

One of the effects of these new regulations was reported in Punch in 1847:

A sort of academic epidemic has broken out among the medical students at the northern end of town; and the youths at the University in Gower Street have not only trenched upon the collegiate trenchers, but have assumed the gown, which ill assorts with the paletot of private life. This strange association of the garb of learning with the habits of the medical students as they live, produces a curious effect; and the neighbourhood of Gower Street has been accordingly startled by the appearance that the combination presents. We have not heard by what authority the assumption of the toga has taken place among the youths of Gower Street; and indeed it requires no less a person than old Gower himself to come forth and explain the mystery.

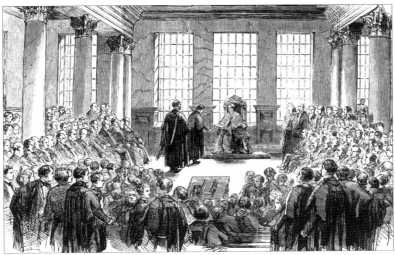

The first University of London Presentation Ceremony

In 1850, the first Presentation Ceremony was held in the Great Hall of King's College London and an engraving of this ceremony appeared in *The Illustrated London News*.

In 1880, the first women graduated. In 1900, the University of London became a federal University. The regulations for academic dress changed around this time and have been added to ever since to form the present system. This system has recently been revised to make is slightly simpler: to

Some of the early women graduates in 1882

take into account the proliferation of degrees, and the change from the traditional degree classifications of Bachelor, Master and Doctor, in the various faculties, to the new classifications of First degrees; Postgraduate Taught degrees; Specialist Doctorates; Research degrees and Higher Doctorates. New robes have also been designed for new degrees. One important change is that there is no longer any distinction, for Doctors, between members

and non-members of Convocation (the voluntary organisation for graduates of the University). Both may now wear the claret or scarlet robe, according to their degree. Bachelors and Masters who are members of Convocation still have the addition of white silk to their hoods. BMus and MMus, who are members, may wear a blue silk gown.

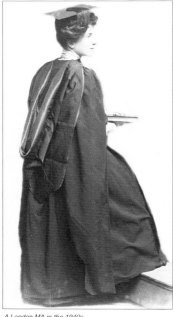

In 1906, the Senate appointed Messrs Ede, Son & Ravenscroft of Chancery Lane, and Mr W Northam of Henrietta Street, Strand (now 119 High Street, Oxford) as official robe-makers to the University.

Over recent years there has been a huge change in the structure and organisation of the University and much more authority has been devolved to the constituent colleges, but the academic costume of the University remains a unifying force within the large federation.

A London MA in the 1940s

The Vice-Chancellor conferring degrees

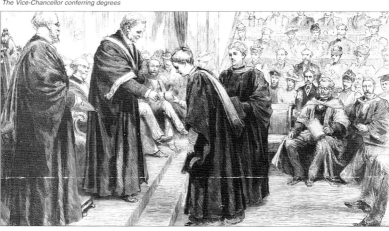

Degrees granted by the University of London

First Degrees

Bachelor of Arts (BA)
Bachelor of Dental Surgery (BDS)
Bachelor of Divinity (BD)
Bachelor of Education (BEd)
Bachelor of Engineering (BEng)
Bachelor of Laws (LLB)
Bachelor of Medical Science
 (BMedSci)
Bachelor of Medicine and Bachelor
 of Surgery (MB BS)
Bachelor of Music (BMus)
Bachelor of Pharmacy (BPharm)
Bachelor of Science (BSc)
Bachelor of Science (Economics)
 (BSc(Econ))
Bachelor of Science (Engineering)
 (BSc(Eng))
Bachelor of Veterinary Medicine
 (BVetMed)
Bachelor of Commerce (BCom)[1]
Bachelor of Humanities (BH)[1]
Master in Science (MSci)
Master of Engineering (MEng)
Master of Pharmacy (MPharm)

[1] No longer awarded

Postgraduate Taught Degrees

Master of Architecture (MArch)
Master of Arts (MA)
Master of Business Administration
 (MBA)
Master of Clinical Dentistry
 (MClinDent)
Master of Education (MEd)
Master of Fine Art (MFA)
Master of Laws (LLM)
Master of Music (MMus)
Master of Pharmacy (MPharm)[1]
Master of Research (MRes)
Master of Science (MSc)

Master of Theology (MTh)
Master of Veterinary Medicine
 (MVetMed)
Master of Commerce (MCom)[1]

[1] No longer awarded

Specialist Doctorates

Doctor in Clinical Psychology
 (DClinPsy)
Doctor in Education (EdD)
Doctor in Educational Psychology
 (DEdPsy)
Doctor in Psychotherapy
 (DPsychotherapy)
Doctor in Public Health (DrPH)

Research Degrees

Doctor of Medicine (MD)
Doctor of Philosophy (PhD)
Doctor of Veterinary Medicine
 (DVetMed)
Master of Dental Surgery (MDS)
Master of Philosophy (MPhil)
Master of Surgery (MS)

Higher Doctorates

Doctor of Divinity (DD)
Doctor of Laws (LLD)
Doctor of Literature (DLit)
Doctor of Literature (Education)
 (DLit(Ed))
Doctor of Music (DMus)
Doctor of Science (DSc)
Doctor of Science (Economics)
 (DSc(Econ))
Doctor of Science (Engineering)
 (DSc(Eng))
Doctor of Science (Medicine)
 (DSc(Med))

The University also grants diplomas and
certificates.

University of London Gowns

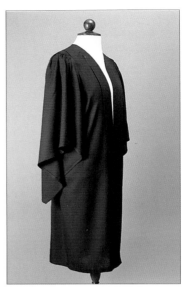

Undergraduate gown

In the University of London, six basic shapes of gowns are used.

For Undergraduates:

A black gown with pointed sleeves, the point not reaching below the knee.

For holders of Postgraduate Diplomas, Postgraduate Certificate in Education and Extra-Mural Diplomas, BA, BD, BEd, BEng, BSc, BCom, BH, MSci, MEng, and any subsequent First Degrees from September 1994:

A black gown with pointed sleeves gathered at the forearm and held in place with a black cord and button.

The BD has a black cord and a Sarum red button on the yoke of the gown at the back.

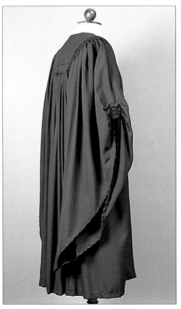

Gown for holders of first degrees in Arts, Education, Engineering, Humanities, Science and Theology

Gown for holders of first and postgraduate taught degrees in Medical Science, Medicine, Music, Pharmacy and Veterinary Medicine

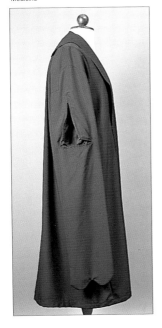

For BDS, BMedSci, MB BS, BMus, BPharm, BVetMed, MPharm, MMus, MVetMed:

A black gown with a square flap collar and long, closed sleeves hollowed out at the ends in a double curve.

BMus and MMus who are members of Convocation may wear this gown made in light blue corded silk (see pages 38 and 39).

For the Research Degrees MS and MDS, the gown is made of violet corded silk and olive green corded silk respectively.

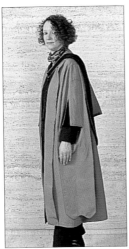

The olive green corded silk gown for the MDS

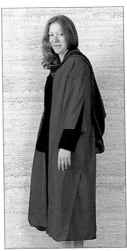

The violet corded silk gown for the MS

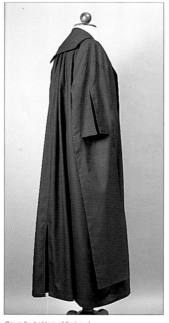

*Gown for holders of first and
postgraduate taught degrees in Law*

For the LLB and LLM:

A black gown with a square flap collar and long, closed sleeves squared off at the ends and a slit in the back of the gown *(the same shape as a Solicitor's gown).*

For Postgraduate Taught Degrees: MA, MArch, MBA, MClinDent, MEd, MFA, MRes, MSc, MTh, MCom, MPhil, and all other postgraduate taught degrees introduced in and after September 1994:

A black gown with long, closed sleeves cut in a forward facing curve at the ends.

For the MTh there is a black cord and Sarum red button on the yoke at the back of the gown.

For the Research Degree of MPhil, this gown has a 1" claret coloured ribbon on the outer edge of the front facings.

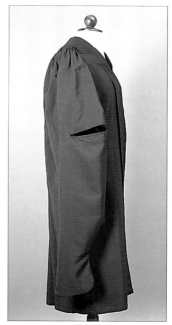

The MA/MSc gown

For Specialist Doctorates, Research Doctorates and Higher Doctorates:

A claret-coloured or scarlet robe with open wing-like sleeves as follows:

DClinPsy, EdD, DrPH, DEdPsy and DPsychotherapy: Claret cloth with facings in front and sleeve linings of ruby (pink) shot silk.

PhD: Claret cloth with facings in front and sleeve linings of lighter claret silk, the outside edges of the facings are bound to show 1" dark blue silk.

MD: Scarlet cloth with facings and sleeve linings of violet silk.

DVetMed: Scarlet cloth with facings and sleeve linings of lilac silk.

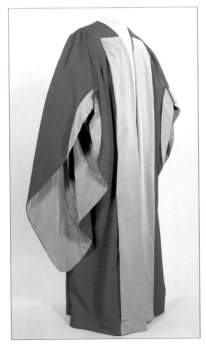

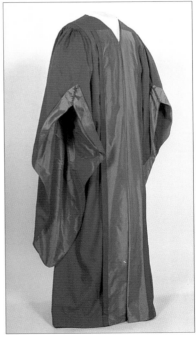

The Specialist Doctorate robe *The Doctor of Philosophy (PhD) robe*

DD Scarlet cloth with facings and sleeve linings of sarum red silk.

LLD Scarlet cloth with facings and sleeve linings of blue silk.

DLit
DLit(Ed)
Scarlet cloth with facings and sleeve linings of russet brown silk.

DMus Scarlet cloth with facings and sleeve linings of white watered silk.

DSc
DSc(Econ)
DSc(Eng)
DSc(Med)
Scarlet cloth with facings and sleeve linings of gold (yellow) silk.

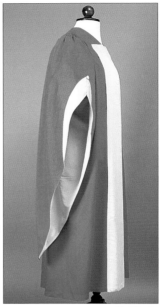

The DSc robe

The fabric

Gowns for undergraduates, diplomates and first degrees are made of black stuff (non-silk material such as woollen cord or polyester), but members of Convocation may wear black silk gowns (light blue corded silk for BMus and MMus).

Gowns for postgraduate taught degrees, and the MPhil, may be of black stuff or silk.

Gowns for the research degrees MDS and MS are of olive green corded silk and violet corded silk.

PhD and specialist doctorate robes are of claret-coloured cloth.

The robes for the MD, DVetMed and higher doctorates are of scarlet cloth.

Where silk is specified, artificial silk may be substituted.

University of London Hoods

All London hoods are of the same shape, similar to that of Cambridge, but with rounded corners to the cape.

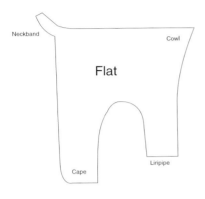

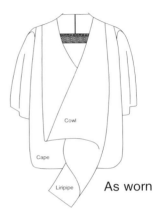

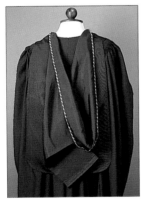

The Diploma hood

Diplomas and Certificates

The hood is of black stuff edged around the cowl with a blue, red and white twisted cord. The neckband is plain.

In addition, some of the constituent Colleges have their own hoods for internal diplomas.

First Degrees

For holders of the first degrees listed overleaf, the hood is made from black silk or stuff (see page 36). The cowl is faced with silk for 3" inside, carried over to form a ⅜" edging on the outside. The neckband is also edged in the same way. The colours are as follows:

BA	Russet Brown
BDS	Olive Green *(corded silk)*
BD	Sarum Red
BEd	Eau-de-nil Green
BEng	Turquoise
LLB	Mid Blue
MB BS	Violet
BPharm	Old Gold
BSc(Econ)	Gold (Yellow
BSc(Eng)	Gold (Yellow)
BVetMed	Lilac
BCom	Deep Orange[1]
BH	Pale Pink[1]

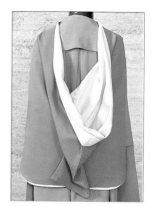

The BMus Convocation hood

[1] No longer awarded

BMedSci: The facing and edging is the same for the MB BS but with a 1" gold (yellow) ribbon around the cowl in the middle of the violet.

BMus: The hood is of light blue corded silk faced inside the cowl with 3" and edged outside with white watered silk.

For any future *Bachelor's* first degrees, the hood will be of black silk or stuff faced inside the cowl with 3" and edged outside with silver grey silk.

MSci	Same as MSc (see page 39).
MEng	Black corded silk fully lined and the cape, cowl and neckband edged with turquoise silk.
MPharm	Black corded silk fully lined and the cape, cowl and neckband edged with old gold silk.

For any future *Master's* first degrees, the hood will be of black corded silk fully lined and the cape, cowl and neckband edged with silver grey silk.

Members of Convocation

Holders of first degrees who are members of Convocation may have hoods fully lined with white silk in addition to the specified facing and edging except for MSci, MEng, and MPharm whose hoods are already fully lined. These may have a facing inside the cowl of 1½" of white silk.

Postgraduate Taught Degrees

The hood is of black corded silk fully lined and edged on cape, cowl and neckband with ⅜" of silk of the following colours:

MArch	Silver Grey
MA	Russet Brown
MBA	Fawn
MClinDent	Silver Grey
MEd	Eau-de-nil Green
MFA	Silver Grey
LLM	Blue
MPharm	Old Gold (No longer awarded as a postgraduate taught degree)
MRes	Silver Grey
MSc	Gold (Yellow)
MTh	Sarum Red
MVetMed	Lilac
MCom	Deep Orange [1]

[1] No longer awarded

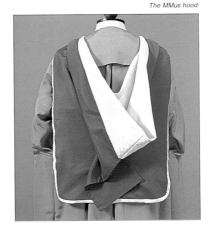

The MMus hood

MMus

The hood is of medium blue corded silk, fully lined and the cape, cowl and neckband edged with white watered silk.

For any future new *Postgraduate Taught Master's* degrees, the hood will be of black corded silk, fully lined and the cape, cowl and neckband edged with silver grey silk.

Members of Convocation
Holders of postgraduate taught degrees who are members of Convocation may have an additional facing of 1½" of white silk inside the cowl of the hood.

Specialist Doctorates

DClinPsy
EdD
DEdPsy
DPsychotherapy
DrPH

The hood is of claret cloth fully lined with ruby silk (a shot silk of pink effect)

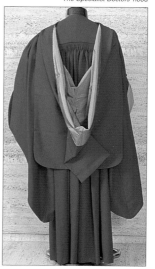

The Specialist Doctors' hood

Research Degrees

MD Scarlet cloth fully lined with violet silk.

PhD Claret cloth fully lined with lighter claret silk. All edges are bound with dark blue silk.

DVetMed Scarlet cloth fully lined with lilac silk.

MDS Black corded silk fully lined and the cape, cowl and neckband edged with olive green corded silk.

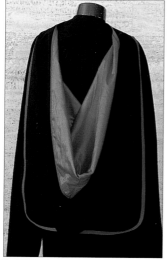

The MPhil hood

MPhil Black corded silk fully lined with claret silk. All edges are bound with dark blue silk.

MS Black corded silk fully lined and cape, cowl and neckband edged with violet silk.

Members of Convocation
Holders of research Master's degrees who are members of Convocation may have an additional facing of 1½" of white silk inside the cowl of the hood.

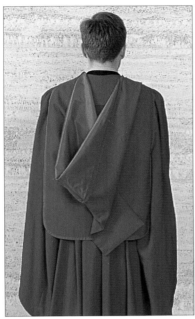

The PhD hood

Higher Doctorates

The hood is of scarlet cloth fully lined with silk as follows:

DD	Sarum Red
LLD	Blue
DLit	Russet Brown
DLit(Ed)	Russet Brown
DMus	White (watered)
DSc	Gold (Yellow)
DSc(Econ)	Gold (Yellow)
DSc(Eng)	Gold (Yellow)
DSc(Med)	Gold (Yellow)

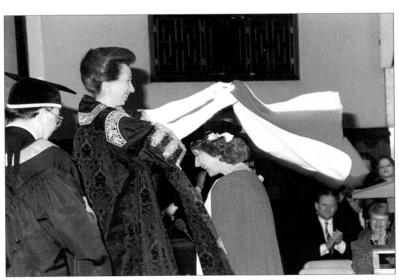

The Chancellor of the University of London, HRH The Princess Royal, awarding the degree of Doctor of Music (honoris causa) to Dame Felicity Lott in November 1997

University of London Caps

Three types of cap are prescribed in the academic dress regulations of the University of London:

Black cloth mortarboard

Oxford Cap

A black cloth mortar-board with a black tassel is worn by undergraduates, holders of certificates, diplomas, first degrees, postgraduate taught degrees and by the MPhil, MDS, and MS. A black cloth soft Oxford cap may be worn by women who hold any of the above awards.

A black velvet Tudor bonnet may be worn by PhDs[1], MDs and DVetMeds, specialist doctors and higher doctors. The cord and tassel colours are as follows:

Specialist Doctors	Claret
PhD	Claret
MD	Violet
DVetMed	Lilac
DD	Sarum Red
LLD	Blue
DLit	Russet Brown
DLit(Ed)	Russet Brown
DMus	White
DSc	Gold (Yellow)
DSc(Econ)	Gold (Yellow)
DSc(Eng)	Gold (Yellow)
DSc(Med)	Gold (Yellow)

Tudor Bonnet

[1] Formerly PhDs wore a black cloth bonnet. Any London Doctor may now wear the bonnet in velvet or cloth.

Robes of the University of London Principal Officers

Chancellor: A black damask robe; front trimmed gold lace and sleeves, back and sides trimmed gold lace and frogs. Cap: A black silk velvet cap of the square mortar-board pattern, trimmed with gold lace and gold tassel or a round cap of black silk damask trimmed with gold.

Pro-Chancellor: A black corded silk robe; fronts, yoke and sleeves trimmed silver lace. Cap: A black velvet cap of the square mortar-board pattern, trimmed with silver lace and black tassel.

Vice-Chancellor: A black corded silk robe; front and sleeves trimmed gold lace. Cap: A black silk velvet cap of the square mortar-board pattern with gold button and band and black tassel.

Chairman of Convocation: A black silk robe; front and sleeves trimmed silver lace and tassels. Cap: A black velvet cap of the square mortar-board pattern trimmed with silver lace and black tassel.

Clerk of Convocation: A black silk gown of the MA pattern with a facing of black velvet. Cap: A black cap of the square mortar-board pattern with black tassel.

Public Orator: A purple silk robe of the MA pattern, faced with dark purple velvet; sleeves faced dark purple velvet and edges piped with silver cord. Cap: A black velvet cap of the square mortar-board pattern trimmed with purple velvet and a silver tassel.

In addition, each constituent College of the University may have distinctive robes for its own principal officers.

At a degree presentation ceremony, the eye is drawn toward the action taking place on the stage or platform to which the graduands come to be presented. The various officers of a university or college wear their official robes and members of the teaching staff wear their academic dress. This makes for a very colourful and striking display since the officers' robes are usually trimmed with gold or silver and members of staff may be wearing the dress of many different universities from Britain and around the world.

The University of London Hoods – First Degrees

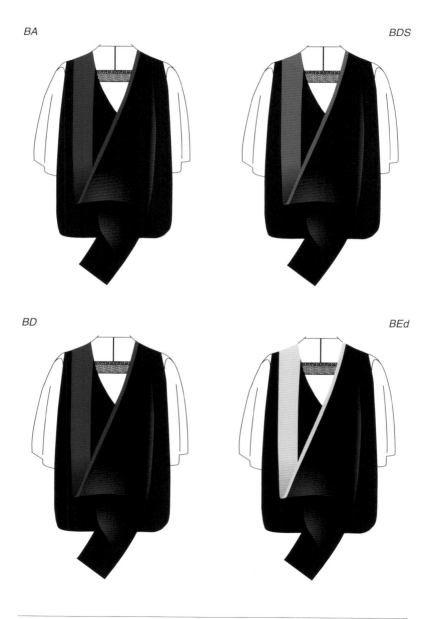

BA

BDS

BD

BEd

First Degrees – continued

BEng

LLB

BMedSci

MB BS

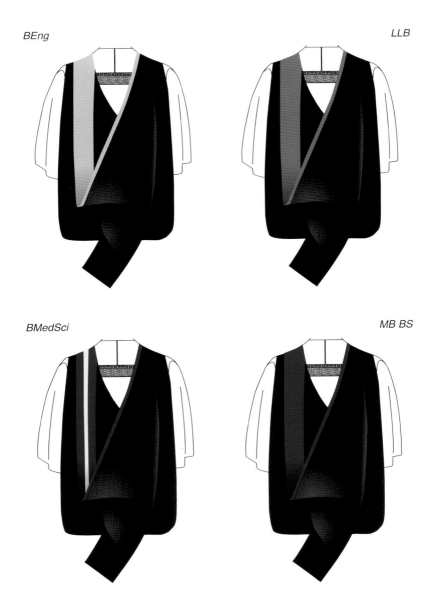

First Degrees – continued

BMus

BPharm

BSc

BVetMed

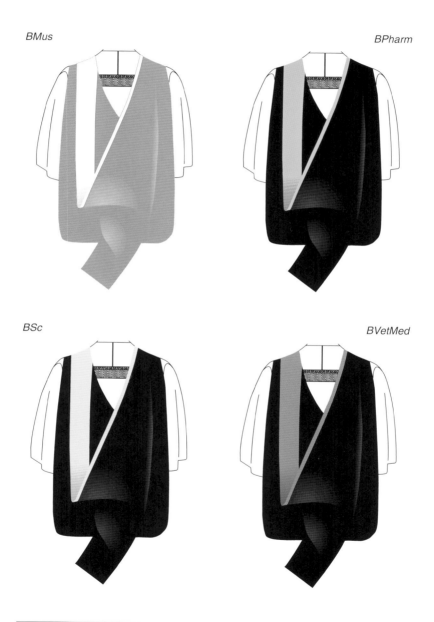

First Degrees – continued

BCom

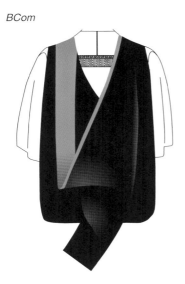

BH

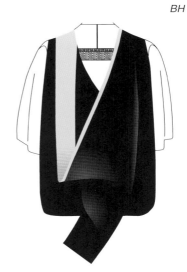

Subsequent new Bachelors

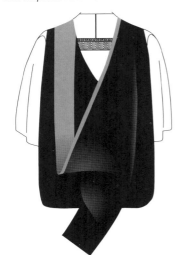

Note:

Bachelors who are members of Convocation may have a white silk lining in addition to the 3" facing.

First Degrees – continued

MSci

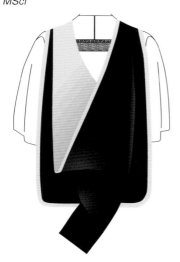

MEng

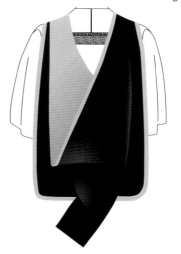

MPharm

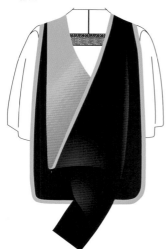

Note:

Masters who are members of Convocation may have a facing of 1½" white silk inside the hood in addition to the lining.

Postgraduate Taught Degrees

MArch
MClinDent
MFA
MRes and
subsequent
taught
Masters

MA

MBA

MEd

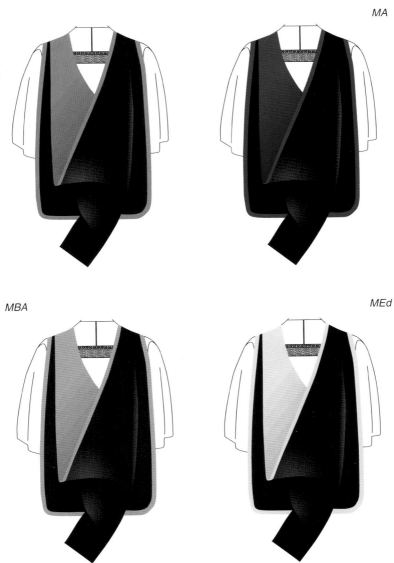

Postgraduate Taught Degrees – continued

LLM

MMus

MPharm

MSc

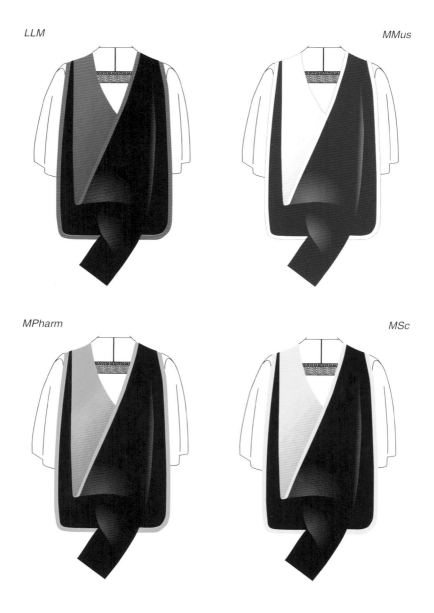

Postgraduate Taught Degrees – continued & Specialist Doctors

MTh

MVetMed

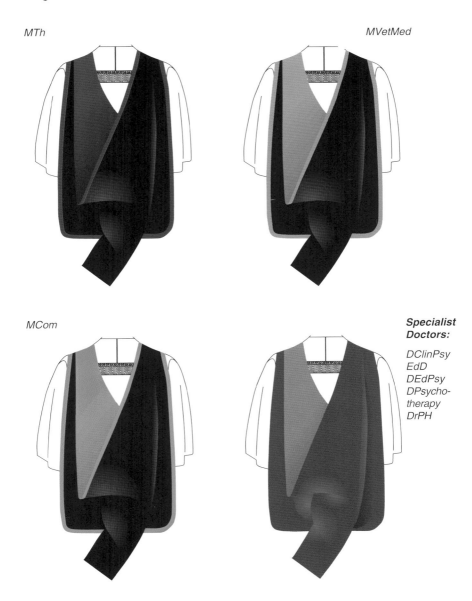

MCom

Specialist Doctors:

DClinPsy
EdD
DEdPsy
DPsycho-
therapy
DrPH

Research Degrees

MDS

MS

MPhil

PhD

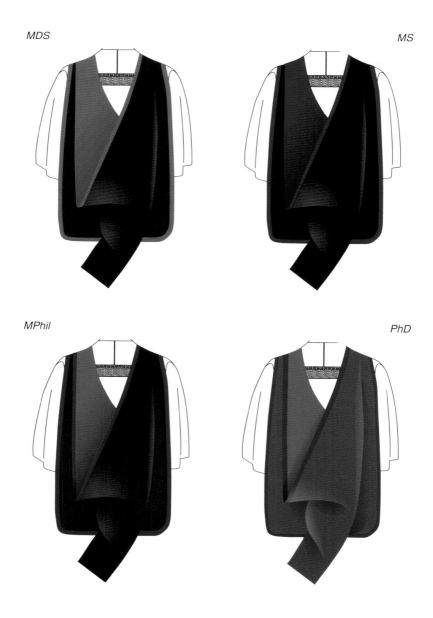

Research Degrees – continued

MD

DVetMed

Higher Doctorates

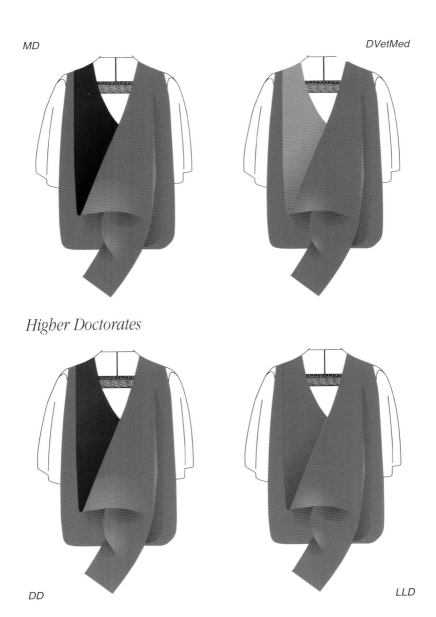

DD

LLD

Higher Doctorates – continued &
Certificates and Diplomas

DLit

DMus

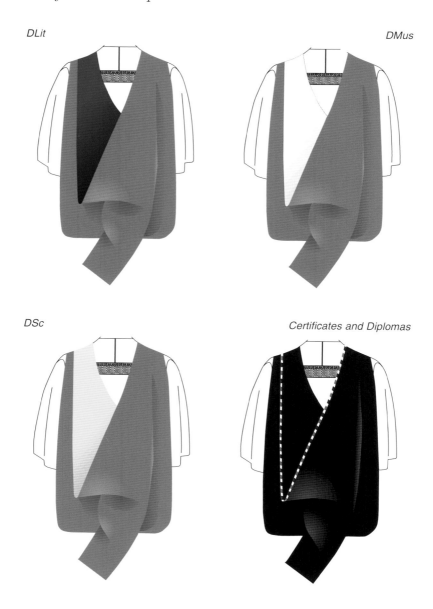

DSc

Certificates and Diplomas

Further reading

Franklyn, CAH
***Academical Dress from the Middle Ages to the Present Day
Including Lambeth Degrees.*** Lewes, England: WE Baxter 1970

Hargreaves-Mawdsley, WH
A History of Academical Dress in Europe. Oxford: Clarendon Press 1963

Haycraft, FW
The Degrees and Hoods of the World's Universities and Colleges.
4th edition revised by Stringer, EWS: Cheshunt Press 1948

Rashdall, WH
The Universities of Europe in the Middle Ages.
Oxford: Clarendon Press 1936 (originally published 1895)

Rogers, FRS, Franklyn, CA, Shaw, GW, Boyd, AH
The Degrees and Hoods of the World's Universities and Colleges.
Lewes: WE Baxter 1970

Shaw, GW
Academical Dress of British and Irish Universities.
Chichester: Phillimore & Co Ltd 1996

Smith, HH, Sheard, K
Academic Dress and Insignia of the World. Cape Town: AA Balkema 1970

Wood, Revd TW
The Degrees, Gowns and Hoods of the British, Colonial, Indian and American Universities and Colleges. Covent Garden: Thomas Pratt & Sons 1887

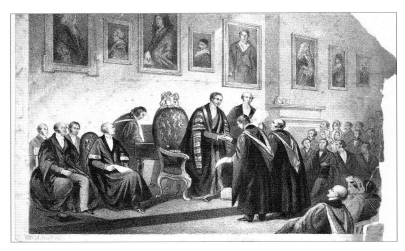

Illustrations